A LAMENT FOR ART O'LEARY:
TRANSLATED FROM THE IRISH BY
FRANK O'CONNOR, WITH SIX ILLUS-
TRATIONS BY JACK B. YEATS, R. H. A.

THE CUALA PRESS
DUBLIN, IRELAND.
MCMXL

PREFACE

The background to 'The Lament for Art O'Leary'
is a historical romance in itself. The author, Eileen
O'Connell, was a daughter of O'Connell of Derry-
nane, one of the great Kerry family, reduced to
smuggling. She knew well that strange ugly old
house we can still see between the wild Kerry
mountains and the Atlantic; a house Selma Lagerlof
would have loved, with its army of retainers and
fosterers, almost beyond the law and hoping to re-
main so. She grew up Irish speaking, with a dash of
English for her dealings with the Protestant 'gentry'
and ships and wine and Continental politics in her
blood. She must have heard the old people talk of
Egan O'Rahilly, the last of the great Gaelic poets
and spoken to herself the bitter lines he made when
he came to their neighbour, Valentine Brown.

An old grey eye, weeping for lost renown,
Has made me a beggar before you, Valentine Brown.

She was wild, for was she not a daughter of Maire
Ni Duibh O' Donoghue, the old witch whom Sean
O'Faolain describes in his 'King of the Beggars'
with her 'muscular intellect, caustic tongue and
power of invective.' She had poetry in her blood for
old Maire, like so many of her kind, turned to poetry
when life smote her. She had an adventurous mind,
for most of that long family had taken the ships'
way to advancement; her brother, Conal, 'Conal
that died by drowning'; her sister, Abby, 'the girl
of six and twenty who went across the water to be a

queen's companion'; wife of one of Maria Theresa's officers and friend of the Empress. It was the story of every great Munster family of the time. Abby's husband was an O'Sullivan, and was it not to another O'Sullivan, Murty Ogue, that Maria Theresa presented a sword — he too like O'Leary, to come home and be slaughtered by the English and remembered in laments by his nurse and serving man? At that time all Europe was full of Irish aristocrats, serving as soldiers of fortune, and Michael Kelly, Mozart's acquaintance, describes his confusion when addressed in Irish by a group of Austrian officers, and his reply to the King of Bavaria 'that in Ireland only the lower classes spoke Irish.' What is strange is that so many of them came back to a country 'where only the lower classes spoke Irish'. Here and there, we still light upon traces of that terrible, gnawing home-sickness. A short time ago I was in a little western cottage, listening to an old man, so old that his voice had lost all expression, tell the story of one of these Wild Geese, an ancestor of his own. He could no longer bear the intolerance and fanaticism of the planters and fought back at them; went on his keeping; fled to France, achieved high rank and (I can still hear that quavering old voice) 'Beat off Wellington on the heights over Saragossa. Grandfather said it.' He married, as so many of them married 'a lady of title and property in the Isle of France,' but in his old age when his wits began to decay they missed him from the house. He was found at last, wandering along the quays of a seaport town and when they took him back he sobbed 'I want to go home to Ballinya.'

Art O'Leary was an officer in the Austrian army. In 1768, he met and married Eileen O'Connell, then a young widow. Her family opposed the match (the O'Connells were notorious for caution, and O'Leary perhaps was a bit of a firebrand.) But at home the position of men like O'Leary and Murty Ogue O'Sullivan was intolerable. By law they were not entitled to possess a horse worth more than five pounds. An English planter, Morris, offered O'Leary the legal sum for his horse; O'Leary replied with a blow, and was made an outlaw. His wife accompanied him, and tradition says, loaded the guns when their house was surrounded by the English. Finally, in 1773, O'Leary was captured and shot dead in Carriganimma. He is buried in Kilcrea churchyard where his epitaph, 'generous, handsome, brave,' can still be read.

An Abbey Theatre dramatist has described this poem as being 'all about food.' Reading a litttle deeper than that, one must find it strange that Eileen Dubh should be at the same time the 'Aunt Nellie' of the family biographer; stranger still that Europe of the Baroque period, the Prince Archbishops, Mozart's music, Saint Germain and Versailles should have been closer to her than the Dublin of Swift. Only a few lines that describe costume remind us that we are dealing with the eighteenth century and not the fourth. Maria Theresa and her court come into it at all only because of the death of the sister, 'who went across the water to be a queen's companion' and so cannot be present at Art O'Leary's wake. The fact is that when they spoke Irish, the Irish aristocrats retreated into a tradition older than history. We

come to the real Eileen Dubh only as 'Aunt Nellie';
the creator of the poem has no existence in time, is
one of Homer's women. The keen or lament was an
extemporized form, differing from the formal elegy
in that it had no regular construction and only such
simple rhythm and rhyming as the rush of emotion
might call up; consequently it is generally more in-
tense, more personal; yet in none of these keens do
we meet with an image which is not of Homeric
kind.

> My love and my fortune,
> 'Tis an evil portion
> To lay for a giant,
> A shroud and a coffin,
> For a big-hearted hero
> Who fished in the hill-streams
> And drank in bright halls
> With white-breasted women.

That approach is conventionalised by the most rig-
orous of traditions, and like Synge's 'Riders to the
Sea' and the noble drawings with which Mr. Yeats
has decorated it, it comes from a world where the
mind has no yesterdays and no tomorrows.
There are many versions. Except for one verse I
have followed the text edited by Mr. Shan O'Cuiv
and used his historical notes.

One hundred and thirty copies of this book have
been printed by Esther Ryan on paper made in Ire-
land, and set in Caslon type by Maire Gill, with
illustrations coloured by Eileen Colum and Kathleen
Banfield. Finished in the third week of May, nine-
teen hundred and forty.

This is Number

Reprinted 1971 by photo-lithography in the Republic of
Ireland for the Irish University Press, Shannon
T. M. MacGlinchey, Publisher
Robert Hogg, Printer
7165 1390 0

THE LAMENT FOR ART O'LEARY.

My love and my delight,
The day I saw you first
Beside the market-house
I had eyes for nothing else
And love for none but you.
I left my father's house
And crossed the hills with you,
And it was no bad choice.
You gave me everything:
Parlours whitened for me,
Rooms painted for me,
Ovens reddened for me,
Loaves baked for me,
Roast spitted for me,
Beds made for me;
I took my ease on flock
Until the milking time
And later if I pleased.

My mind remembers
That bright spring day,
How a hat with a band of gold became you,
Your silver-hilted sword,
Your manly right hand,
Your horse on his mettle,
The foes around you
Cowed by your air
For when you rode by
On your white-nosed mare
The English bowed
To the ground before you,
Out of no love for you,
Out of their fear,
Though sweetheart of my soul,
The English killed you.

Rider of the white palms,
How a brooch became you
In a shirt of cambric!
And your hat with laces —
When you rode there,
And their streets were bare,
'Twas no love that stayed them
But hatred and fear.

My love and my calf
Of the race of the earls of Antrim
And the Barrys of Eemokilly,
A sword became you.
A hat with a band,
A slender foreign shoe
A suit of yarn
Woven over the water.

My love and my secret
'Tis well you were suited
In a five-ribbed stocking
Your legs top-booted,
Your cornered Caroline
Your cracking whip.
Your sprightly gelding —
Oh, many's the girl
That would stop to behold you!

My love and my sweetheart,
When I come back
The little lad Conor
And Fiach the baby
Will ask me surely
Where I left their father;
I will say with anguish
'Twas in Kilnamartyr —
They will call the father
That will never answer.

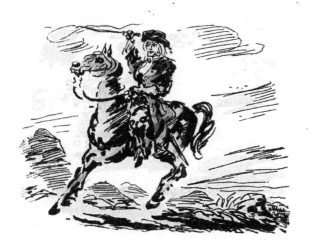

My love and my darling
That I never thought dead
Till your horse came to me
With bridle trailing,
All blood from forehead
To polished saddle
Where you should be,
Sitting or standing;
I gave one leap to the threshold,
A second to the gate,
A third upon her back.

I clapped my hands
And off at a gallop,
I did not linger
Till I found you dead
By a little furze-bush,
Without pope or bishop
Or priest or cleric
One prayer to whisper,
But an old, old woman
And her cloak about you,
And your blood in torrents,
Art O'Leary,
I did not wipe it up,
I cupped it in my hands.

My love and my delight,
Rise up now beside me,
And let me lead you home!
Until I make a feast
And I shall roast your meat,
And send for company
And call the harpers in;
And I shall make your bed
Of soft and snowy sheets,

And blankets dark and rough
To warm the beloved limbs
An autumn blast has chilled.

(His sister speaks)

My little love, my calf!
This is the vision
That last night brought me,
In Cork all lonely
On my bed sleeping,
That the white courtyard
And the great mansion
That we two played in
As children had fallen;
Ballingeary withered,
And your hounds were silent,
Your birds were songless,
The while they found you
On the open mountain
Without priest or cleric
But an old, old woman,
And her coat about you,
When the earth caught you,
Art O'Leary,
And your life-blood stiffened
The white shirt on you.

My love and my treasure!
What fine lovely lady
From Cork of the white sails
To the bridge of Tomey
With her dowry gathered
And cows at pasture
Would sleep alone
The night they waked you?

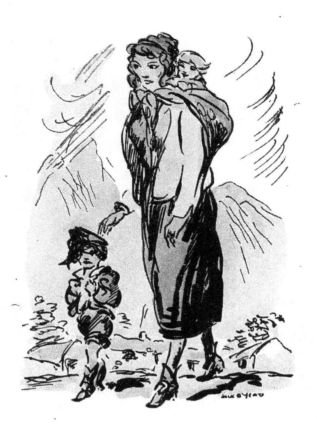

(Eileen O'Connell replies)

My darling, do not believe
One word she is saying!
It is a lie
That I slept while others
Sat up and waked you —
'Twas no sleep that took me
But the children crying:
They would not close their eyes
Without me beside them.

Oh, people, do not believe
Any lying story!
There is no woman in Ireland
That had slept beside him
And borne him three children
But would cry out
After Art O'Leary
That lies dead before me
Since yesterday morning.

Grief on you, Morris!
Heart's blood and bowel's blood!
May your eyes go blind
And your knees be broken!
You killed my darling
And no man in Ireland
Will fire the shot at you!

Grief and destruction!
Morris the traitor!
That took my man from me,
Father of three children;
There are two on the hearth
And one in the womb
I shall not bring forth.

My love and my sweetness,
Art, rise up to me,
And leap upon your mare,
And ride into Macroom
And Inchigeela beyond,
Clasping your flask of wine,
One going, one coming back,
As in your father's time.

My lasting misery
I was not by your side
The time they fired the shot
To catch it in my dress
Or in my heart, what harm,
If you but reached the hills,
Rider of the ready hands.

My love and my fortune,
'Tis an evil portion
To lay for a giant,
A shroud and a coffin;
For a big-hearted hero
That fished in the hill-streams,
And drank in bright halls
With white-breasted women.

My love and my delight,
As you went out the gate,
You turned and hurried back,
And kissed your handsome sons,
You came and kissed my hand.
And said 'Eileen, rise up,
And set your business straight,
For I am leaving home,
I never may return.'
I laughed at what you said,
You had said as much before.

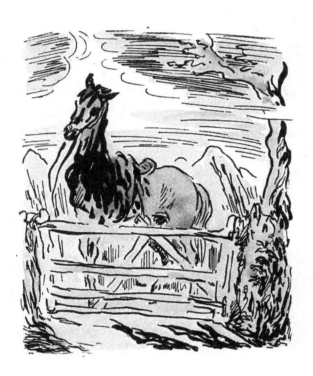

My husband and my friend,
Master of the bright sword,
Rouse yourself from this sleep,
Put your best things on,
Put your gauntlets on,
Take your beaver hat
Yonder hangs your whip!
Your horse is at the door,
Follow the small road east
Where every bush will bend
And every stream dry up,
And man and woman bow
If things have manners yet
That have them not I fear.

My love and my delight,
'Tis not my people's death,
'Tis not my children's death
Nor Donal Mor O'Connell,
Conal that died by drowning
Nor the girl of six and twenty
That went across the water
To be a queen's companion,
'Tis not all these I speak of
And call on with voice broken
But noble Art O'Leary,
Art of hair so golden,
Art of wit and courage,
Art the brown mare's master,
Swept last night to nothing
Here in Carriganimma —
Perish it, name and people!

My love and my treasure,
Though I bring with me
No throng of mourners
'Tis no shame for me,
For my kinsmen are wrapped in
A sleep beyond waking
In narrow coffins
Walled up in stone.

Though but for the smallpox
And the black death
And the spotted fever,
That host of riders
With bridles shaking
Would rouse the echoes,
Coming to your waking,
Art of the white breast!

Ay, could calls but wake my kindred
In Derrynane across the mountains,
And Carhen of the yellow apples,
Many a proud and stately rider,
Many a girl with spotless kerchief
Would be here before tomorrow,
Shedding tears about your body,
Art O'Leary once so merry!

My love and my secret,
Your corn is stacked,
Your cows are milking;
On me is the grief
There's no cure for in Munster.
Till Art O'Leary rise
This grief will never yield
That's bruising all my heart,

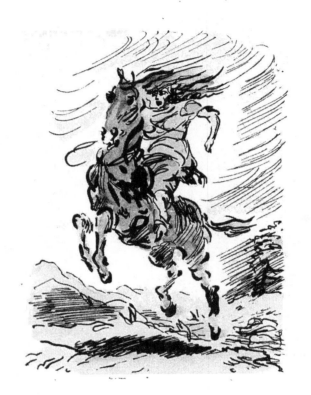

Yet shut up fast in it,
As 'twere in a locked trunk
With the key gone astray
And rust grown on the wards.

My love and my calf!
Noble Art O'Leary,
Son of Conor, son of Cady,
Son of Lewis O'Leary,
West of the Valley,
And east of Greenan
(Where berries grow thickly
And nuts crowd on branches,
And apples in heaps fall
In their own season)
What wonder to any
If Iveleary lighted
And Ballingeary,
And Gugan of the saints
For the smooth-palmed rider
The huntsman unwearied
That I would see spurring
From Grenagh without halting
When quick hounds had faltered?
Oh, rider of the bright eyes
What happened you yesterday?
I thought you in my heart
When I bought you your fine clothes
One the world could not slay.

My love and my delight,
Kin of the hardy horsemen
That would hunt all the glens
Till you had turned them home
And led them to the hall
Where tables would be spread,
Sharpness being put on knives,

Roasted beef being cut,
Bacon fit to eat,
Many a rib of mutton,
Oats in plenty hanging
To set the horses neighing —
Hairy slender horses
Flanked with sturdy horseboys,
Never charged their lodging,
Nor their horses' feeding
Had they stopped a fortnight.

'Tis known to Jesus Christ
Nor cap upon my head
Nor shift against my side
Nor shoe upon my foot
Nor gear in all my house
Nor bridle for the mare
But I will spend at law;
And I'll go oversea
And plead before the king,
And if the king be deaf
I shall come back alone
To the black-blooded thief
That slew my man on me.

Oh, rider of the white palms,
Go you to Baldwin,
And face the schemer,
The bandy-legged monster
May he rot and his children
(Wishing no harm to Maire *
Yet of no love for her,
But that my mother's body
Was a bed to her for three seasons
And to me beside her).

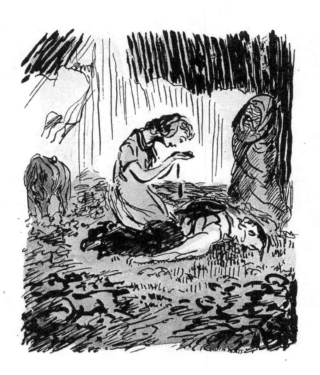

Take my heart's love,
Dark women of the Mill
For the sharp rhymes ye shed
On the rider of the brown mare —

But cease your weeping now,
Women of the soft, wet eyes,
Till Art O'Leary drink,
Ere he go to the dark school,
Not to learn music or song
But to prop the earth and the stone.

<div align="right">Eileen O'Connell.</div>

(Her twin sister married to Baldwin of Macroom.)*

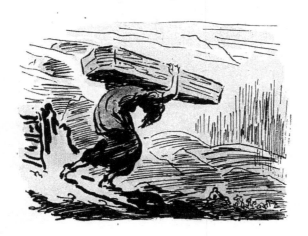

9 781014 113931